David Hockney

David Hockney

Helen Little

Tate Introductions
Tate Publishing

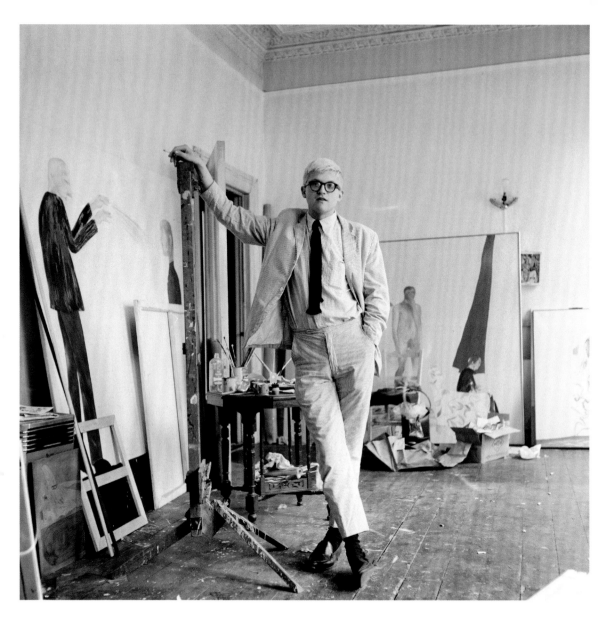

I'm interested in ways of looking and trying to think of it in simple ways. If you can communicate that, of course people will respond. Everyone can look. It's just a question of how hard they're willing to look, isn't it?

Recorded during a television interview in the 1980s, David Hockney's response to being asked 'What makes you popular?' not only suggests why his work appeals to a large number of people but sums up the major line of enquiry that has been the main pursuit of his sixty-year career. As one of the greatest figurative artists of the twentieth century, Hockney's images, whether in the form of painting, drawing, print, stage design or iPad, have consistently challenged the way we look at the world. Like his hero Pablo Picasso, whose art moved through numerous phases and different approaches and styles with great frequency, with each direction and new body of work Hockney has challenged the orthodoxies of picture-making and the idea of a signature style. Tackling the challenge of how movement, time and space can be captured in two dimensions, he sees this urge to view the world through his art as a continual journey, declaring: 'The history of pictures begins in the caves and ends, at the moment, with an i-Pad. Who knows where it will go next?[1]

Early life in Bradford
David Hockney was born in the industrial city of Bradford, Yorkshire, on 9 July 1937, the son of Kenneth and Laura Hockney and the fourth of five children (fig.2). Growing up in post-war austerity, his was the last generation to do so without television and with rationing in place until he reached the age of sixteen. A powerful early influence was film: 'I've always said I was brought up in Hollywood and Bradford', he maintains, referring to regular trips by bus – he would always ride at the front of the upper deck in order to see *more* – to 'the pictures'.

5

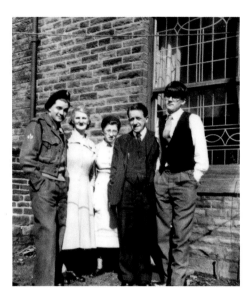

It was here that Hockney's imagination was set free to wander the plains of the American Wild West or the imaginary realm of the silver screen (he recently related his favourite film, the 1952 musical *Singing in the Rain*, to his interest in the stage, performance and artifice).[2] 'Because you were sitting near the front the edges of the screen seemed unimportant, they were miles away,' he recalls, 'whereas now I'm aware of the edges of a screen.'[3]

Steeped in Methodist culture, Hockney's parents' values favoured practicality and hard work. Always drawing – and academically gifted, although he flunked his exams at Bradford Grammar School in protest of their failure to offer sufficient art classes to the brightest students – in 1953 he enrolled at Bradford School of Art where his fellow students included Norman Stevens, David Oxtoby and John Loker. There he received a traditional art training based on life drawing and faithful observations of the exterior world, producing paintings and lithographs characterised by sombre colours and illusionistic space in the style of the Euston Road School. A number of earnest but confident self-portraits hint at his admiration for Stanley Spencer, another English artist positioned outside the canon of modernism and whose eccentric style and distinctive pudding-bowl haircut Hockney emulated (fig.3). Subsequent student works, ranging from domestic interiors, fish and chip shops and portraits of family

2. Hockney with his family in Bradford, May 1954

6

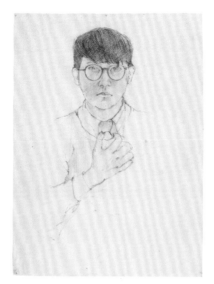

3. *Self-Portrait* 1954
Graphite on paper
38.1 × 27.9
The David Hockney
Foundation

members, were commended for their technical ability and Hockney received early recognition, exhibiting and selling *Portrait of my Father* at the 1957 Yorkshire Artists Exhibition at Leeds Art Gallery. Britain still had compulsory national service in 1957, and the twenty year-old Hockney, having inherited his father's radical worldview, registered as a conscientious objector and worked for two years for the National Health Service in hospitals in Bradford and Hastings. He rarely painted during this time, but spent his time reading poetry and other forms of literature and visited several exhibitions including the American abstract expressionist Jackson Pollock at the Whitechapel Art Gallery in 1958. He also became an avid campaigner, designing placards for the Campaign for Nuclear Disarmament, attending the 1958 march at Aldermaston and becoming a militant vegetarian.

When Hockney moved to London in 1959 most of his experience of modern art had come from volumes of Albert Skira's *The Taste of Our Time* series of books on art, a crucial window to the world which prompted him to marvel about how pictures are made.

Queering Abstract Expressionism
In 1959, as British art school education was undergoing a period of rapid transformation, Hockney began a two-year MA Painting course at London's Royal College of Art (fig.4). There students of painting,

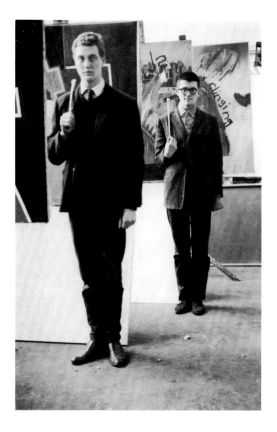

fashion and design worked closely together and were interested in the interaction of arts, crafts and design, the student magazine *ARK* advocating that art should be more open to artists' surroundings and to the visual sources of the time. Unclear as to which direction his work should take but aspiring to be a 'modern' artist, after dutifully concentrating on a series of academic drawings at the end of his first year Hockney produced a body of work that dealt increasingly with propagandising his outlawed homosexuality. Highly experimental and often quoting incongruous styles, pictorial conventions and concepts of space, this new mode of self-referential depiction developed quickly in his painting.

Although American abstract expressionism had become the principle focus for many young painters in London art schools around 1960, it was the work of an older generation of British artists – specifically Roger Hilton and Alan Davie – that had a

5. *Myself and My Heroes*
1961
Etching and aquatint
on paper
25.7 × 50.2
Tate. Purchased 1979

more decisive effect on the development of Hockney's art at this time. A small group of oil paintings he made at the end of his first year suggests it was through encountering Davie's free-flowing, spontaneous canvases of the late 1940s and 1950s at Wakefield Art Gallery in 1958 that Hockney felt able to experiment with the modern language of abstraction. This is evident in the splashy and scrawled ovoid forms set against the white ground of *Tyger Painting no. 2* 1960 which introduces urgently scrawled graffiti as part of the artist's construction of a pictorial message without conforming to conventions of figuration and illusionism.

Hockney began to further blur the distinctions between abstract and representational painting by employing schematic figures, graffiti and cryptic codes derived from the American poet Walt Whitman to convey the themes of sex and love. As one of the earliest of Hockney's coming out works, *Shame* 1960 (fig.21) references the artist's sexuality in a way that is both celebratory and awkward, the self-portrait grasping the grey phallus that dominates the picture plane anticipating another self-portrait in the etching *Myself and My Heroes* 1961 (fig.5). Other works take the theme of loving relationships between men, both real and imaginary. In *The Third Love Painting* 1960 (fig.22), a figure gives the impression of reaching towards a large phallic shape set against a background covered with

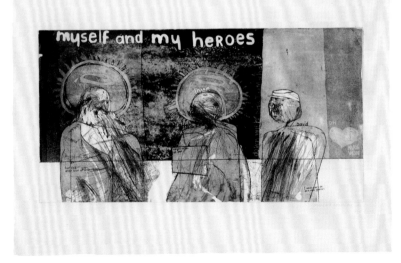

scribbled phrases – some taken from the lavatory walls of Earl's Court underground station – including the lines 'ring me anytime at home' and 'come on David admit it.' In another series Hockney explores male desire through the relationship between two figures. In more sexually explicit paintings such as *Cleaning Teeth, Early Evening (10pm) W11* 1962 (fig.24), schematised male bodies, identified conceptually by codes of numbers corresponding to letters of the alphabet, are situated in areas of spatial ambiguity, offering recognisable imagery while retaining the formal contrasts of texture and brushwork. As he became more unabashed by his sexuality, boyfriends and crushes – most notably the pop star Cliff Richard, who the artist nicknamed 'doll boy' – began to appear as principle figures in more direct and complex examinations of male desire.

Demonstrations of versatility

In 1961 Hockney took part in the *Young Contemporaries* exhibition which brought the work of students at the RCA including Barry Bates, Patrick Caulfield, Allen Jones, R.B. (Ron) Kitaj and Peter Phillips to a wider public attention – as well as to the press, who were quick to situate them in the canon of pop art. By harnessing the language of the dominant abstract painting of the time and subverting its high-art values by associating it with the world around him, Hockney's work was championed as part of the post-war development of figuration that jolted the viewer into a new sense of the contemporary. It was at this time that Hockney's work caught the eye of the emerging gallerist John Kasmin, who purchased *Doll Boy* for £40. By July 1962, with plans underway for his new cutting edge gallery on Bond Street, Kasmin had become Hockney's official dealer. This early commercial success enabled Hockney to finance his first trip to America, which is re-enacted in the suite of sixteen etchings *A Rake's Progress* 1961–3 based on William Hogarth's satirical prints of the eighteenth century. Positioning himself as a contemporary Hogarth, here Hockney uses line to tell a confessional tale of his experience as a young gay man arriving in New York. In a modern version of the grand tour in which privileged young men set off for Europe on voyages of education and self-revelation, the first plate, 'The Arrival', sees the semi-autobiographical protagonist approaching the city, recognisable by his phallic interpretation of the Chrysler Building (fig.6). Impressed by

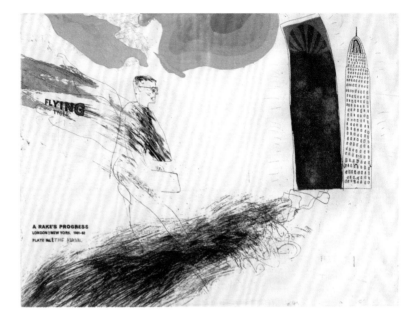

6. 'The Arrival' from
A Rake's Progress 1961–3
Etching and aquatint
on paper
39.4 × 57.2
Tate. Purchased 1971

the scale of the abstract paintings he had seen in New York and keen to distance himself from the pop label, Hockney exhibited four paintings under the title 'Demonstrations of Versatility' in the 1962 Young Contemporaries exhibition.[4] In each he employed a variety of styles and modes of representation to critique conventions of artistic expression and debunk the idea of an autograph style. As he later described, 'I deliberately set out to prove I could do four entirely different sorts of picture like Picasso.'[5] Playing with the different realities offered by painting and investigating the paradox between flatness and illusory depth, *Tea Painting in an Illusionistic Style* 1961 (fig.23); also known as 'The Third Tea Painting') features a male figure painted in the style of Francis Bacon squatting within the confines of a narrow cubicle in the shape of a Typhoo Tea packet. Employing a shaped canvas to encourage a trompe l'oeil impression, Hockney draws attention to both the flatness and the object quality of the painting.

Despite having failed his general studies course, in July 1962 Hockney graduated from the RCA, winning the College Life Drawing Prize and the top award of the Gold Medal for Work of Outstanding Distinction. Having discovered that anything could become a subject for his art, Hockney left having developed a stylistic freedom that

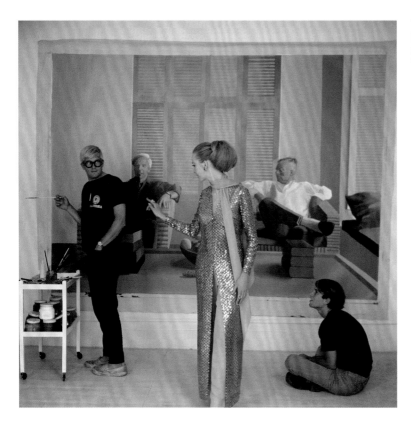

7. Cecil Beaton
David Hockney, Peter
Schlesinger and a model,
Vogue 1968

would characterise his work as a mature artist. As he summed up in his statement for the Grabowski Gallery's *Image in Progress* exhibition that year, 'I paint what I like, when I like, and where I like, with occasional nostalgic journeys.'[6]

Artifice and illusion

After leaving the Royal College, Hockney lived on Powis Terrace in London's Notting Hill, where he made work that continued to blend the visible world and daily life, literature and art history into witty but intelligent investigations into the possibilities and flaws of depiction. As part of a new generation of artists who developed innovative ways to deal with modernity, Hockney's growing celebrity was charted in the context of Swinging London and the celebration of meritocracy that was part of the new social mobility and affluence of the 1960s. Positioned as seductively different, his work appeared in glossy

magazines of the day including *Town, Queen, Vogue* and *The Sunday Times Colour Supplement*, where it became attractive to the swinging elite who sought a fashionable alignment to his anti-establishment position (fig.7).

After the group exhibition *British Painting in the Sixties* at the Whitechapel Art Gallery in 1963, *The First Marriage (A Marriage of Styles)* 1962 was acquired by the Tate Gallery – the first work by Hockney to enter its collection (fig.26). Employing a pastiche of styles, it captures a strange observation on a visit to Berlin's Pergamon Museum of his companion standing in profile at the end of a corridor next to an ancient Egyptian seated wooden figure. Interested in the idea of a 'marriage of styles' between these two people – ancient and modern, real and unreal – Hockney presents each of them naturalistically and schematised, the bare canvas behind them emphasising their flatness and preventing the spectator from sensing any illusion on its surface.

Hockney's sell-out first solo exhibition *Paintings with People In* at Kasmin Gallery in 1963 presented a series of portraits of male couples in domestic settings, their storylines characterised by commitment and companionship. Based on observation and imagination, their spaces are suggested by individual props – a sofa, coffee table or vase of flowers – rather than details of its interior architecture, the artist explaining, 'Vision is like hearing, it is selective, you decide what's important, which means that other factors are determining what you see as well.'[7] A dominant feature in this body of work are curtains that draw attention to the passage of light as a source of reality around which the paintings are constructed, yet simultaneously announce the works as theatrical spaces of illusion and artifice. The poses of the male figures in *Domestic Scene, Los Angeles* 1963 (fig.27) – one showering while the other, dressed in white gym socks and an apron, washes his back – were borrowed from the soft-core male nudist magazine *Physique Pictorial*, whose homoerotic images disguised as physical culture poses cultivated Hockney's impression of California as a paradise of beautiful scantily clad boys.

Later that year, Hockney left London for New York, where he met the American pop artist Andy Warhol and Henry Geldzaher, curator of contemporary art at The Metropolitan Museum of Art, who would later appear as subjects in his work. Back in London, he saw

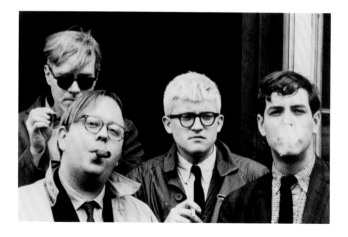

the Baroque artist Domenchino's *Apollo Killing Cyclops* 1616–18 in the National Gallery. That picture's drama and very shallow depth prompted Hockney to employ the curtain to even greater dramatic effect in *Play within a Play* 1963 (fig.28). Here the shallow foreground traps the figure of his friend John Kasmin between an elaborate tapestry and a sheet of Perspex attached to the surface of the canvas, painted with his hands and clothes where they appear to touch its surface. By drawing from such a range of artistic devices, old and new, Hockney experimented with double levels of reality, situating his subjects between what he referred to as 'this small space of art and life'.[8]

California

Los Angeles had become an important location for Hockney's sexual fantasies before his first visit in January 1964. By the end of the decade, Hockney was known as *the* painter of California, 'the nursery of modern homosexuality'. Hockney was drawn to its beach communities 'because I sensed the place would excite me. No doubt it had a lot to do with sex.'[9] When confronted with its reality, he immediately began to paint the glamorous setting and people of LA as an ideal world of symmetrical landscapes, glamorous swimming pools and interiors enhanced by the brilliant Californian sunshine, perpetually youthful and modern.

Yet Hockney's LA paintings are not straightforward representations of actual scenes or sites. Rather, his technicolour images present the

9. 'David Hockney accepts first prize in the John Moore's Liverpool Exhibition. Pictured with his painting *Peter Getting out of Nick's Pool* at the Walker Art Gallery', *Liverpool Echo,* 21 November 1967

city as a tropical utopia' as though it were an outpost of an empire,' as one art historian suggests – rather than one troubled by social and racial tensions, or as one of the most super profitable centres of industry in the world.'[10] In his study of a modernist office block, *Savings and Loans Building* 1967 (fig.33), the formal concerns of post-painterly abstraction and minimalism are kept in check, the deftly painted lattice of blue squares that shimmers across the picture plane insisting on the formality and flatness of the grid. The artificiality of the image is further emphasised by Hockney's use of acrylic paint, whose matt texture depersonalises the surfaces and subjects of his canvases. Their coolness also derives from his growing interest in photography as an *aide-mémoire* and his use of borders – strips of bare canvas around the image – to echo the format of a Polaroid photograph.

In 1967, the year homosexuality was decriminalised in Britain, Hockney was awarded the John Moore's Prize for *Peter Getting out of Nick's Pool* 1966 (fig.9). In contrast to this sexy portrait of the artist's then boyfriend, the art student Peter Schlesinger, in *A Bigger Splash* 1967, human presence is only implied (fig.32). Painted when Hockney was teaching at the University of California, Berkeley, it is the culmination of his obsession with the problem of representing water in motion and pursuing the extremes of instantaneity in his pictures. Here the picture's title and the ejaculatory form of the splash, laboriously painted with a small brush over several weeks, perverts the abstract expressionists' concept of action painting and finding images

'in the moment'. Invited to enter the picture via the diagonal yellow diving board, the viewer is caught in a dramatic moment in time of both movement and stasis, the monochromatic water offering no possible development. As the English art critic Charles Harrison noted, 'The figure whose plunge is recorded by the splash will never surface in this world.'[11]

Naturalism and realism

In 1970, Hockney's first retrospective, *David Hockney: Paintings, Prints and Drawings 1960–1970*, opened at London's Whitechapel Art Gallery. Bringing together over a hundred works, it revealed Hockney's development of the increasingly naturalistic representations of light, shadow and human figures that were becoming key ingredients in his visual language. Having employed drawing as a medium for observing the world around him as directly as possible from the mid-1960s, Hockney also became increasingly occupied with painting images imbued with an emotional response to people and places as he saw them. This position coincided with his purchase in 1967 of a 35mm Pentax camera whose pictures offered greater subtleties in light, focus and format and were in turn used to develop compositions with a greater illusion of space and depth. Yet, ever distrustful of the camera's ability to capture what the eye can see, Hockney preferred to paint his figures from life.

This approach formed the basis of the carefully staged double portraits that became Hockney's principle occupation for the decade after 1968. Here, couples and friends are depicted in their homes, combining informal poses and settings with the grandeur and formality of traditional portraiture. Almost life-sized, and governed for the first time by one-point perspective, paintings such as *Christopher Isherwood and Don Bachardy* 1968 evoke the presence of their subjects in real space, inviting the viewer to take the artist's place and become a participant in complex emotional dramas. Having depicted his lover's naked body in a number of intimate scenarios (fig.30), in *Portrait of an Artist (Pool with Two Figures)* 1971–2 Hockney paints Peter to appear introspective and remote from the viewer and the distorted swimmer he looks down upon (fig.36). Contrasting the naturalistic rendering of the landscape, the pool and figure are carefully patterned and highly abstracted –

'as if', as one observer described, 'the standing boy is staring deep into a perfect picture, thoroughly seduced yet fully aware of its utter inaccessibility.'[12]

Hockney struggled with the technical demands of painting *contre-jour* or against daylight in the unconventional marriage portrait *Mr and Mrs Clark and Percy* 1970–1 (fig.34). Demanding more photographic studies than ever before, it presents the artist's friends, the designers Ossie Clark and his new wife Celia Birtwell, in their bedroom in Notting Hill, separated by a large open window and surrounded by objects of personal significance. Defeated by what he called the 'trap of naturalism' and the problems of uniting figures, composition and light using acrylic, Hockney temporarily abandoned double portraits after 1972. After travelling to Japan, and living in Paris, he experimented briefly with still life and returned to oil painting, making two further paintings with figures, *My Parents* 1977 and *Looking at Pictures on a Screen* 1978 which presents his friend Henry Geldzahler inspecting some reproductions of historical paintings in his studio. This theme of looking at a picture of looking at pictures became the basis for Hockney and the artist R.B. Kitaj's

10. 'No Joy at the Tate', *Observer*, Sunday 4 March 1979. Tate Archive

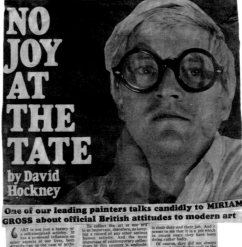

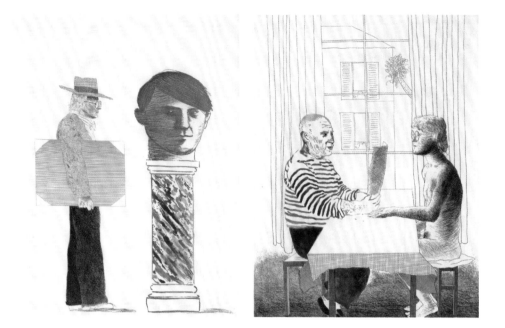

argument in *The New Review* against what they perceived to be a neglect of figurative painting, declaring 'It's always figures that look at pictures. It's nothing else. There's always a little mirror there.'[13] Subsequently, in an article for the *Observer* headlined 'No Joy at the Tate', Hockney criticised the Tate Gallery for its apparent bias towards abstract art, questioning whether the diversity of modern art had been properly represented in British institutions. (fig.10)[14] Consequently, Hockney continued to revaluate modernism on his own terms.

New ways of seeing

After Picasso's death in 1973, Hockney was invited to produce a work in homage to the giant of twentieth century art. His response came in the form of two self-portrait prints, *The Student, Homage to Picasso* and *Artist and Model* (both 1973), which he made in Paris after learning the advanced etching technique of sugar lifting with Picasso's master printer Aldo Crommelynck (figs.11–12). Hockney's reencounter with Picasso also led him to produce his largest and most innovative suite of colour etchings, *The Blue Guitar* 1976–7, based on Wallace Stevens' poem about the role of artistic imagination

11. David Hockney
The Student, Homage to Picasso
1973
Etching
57.2 × 43.5
National Portait Gallery, London

12. David Hockney
Artist and Model
1973
Etching
57 × 44

13. Hockney on the set
of *The Rake's Progress*,
Sadler's Wells, London

and interpreting reality, which to Hockney's delight was based on Picasso's blue period painting *The Old Guitarist* 1903.

In his 1977 autobiography, Hockney described how it was through the space of theatre that he was able to break through into new visual territory. In 1974 he was commissioned to design a production of Stravinsky's opera *The Rake's Progress* to be presented at Glyndebourne the following summer (fig.13). This was the first of a series of opera designs which freed up Hockney's painting as it prompted him to work with three dimensional models to uncover new ideas of space that would be experienced emotionally by an audience. Drawn entirely in cross-hatched pen lines, Hockney's design revisited his earlier etchings of the story. Having concluded that one-point perspective freezes time and excludes viewers from pictures, his discovery of an eighteenth-century treatise on the rules of perspective by Joshua Kerby led to a new kind of painting as seen in *Kerby (After Hogarth) Useful Knowledge* 1975 which playfully demonstrates as many perspectival flaws as possible and shatters the ideal of fixed space (fig.39).

After seeing Picasso's retrospective at the Museum of Modern Art, New York in 1980 and producing a series of energetic canvases for the French Triple Bill at the nearby Metropolitan Opera House in 1981, Hockney embarked on a series of expressive landscapes that

favoured the rhythm and harmony of colour over representation and that described certain landscapes experienced bodily in time. Working more quickly than ever before, in *Nichols Canyon* 1980 he simplified the forms of the landscape into a continuous surface pattern of abstract shapes, textured curves and horizontal stripes, the vivid yellows, reds, blues and greens a nod to early twentieth century French painting as well as LA's spectacular sunsets (see frontispiece). By this time, Hockney was living in the Hollywood Hills and commuting by car to his studio in Santa Monica. This journey formed the basis of *Outpost Drive, Hollywood* 1980 and the monumental panorama-cum-map *Mullholland Drive: The Road to the Studio* 1980, which attempts to convey the sense of motion and altitude of this daily experience (fig.14). Utilising a visual logic centred on movement rather than the photographic wide angle lens, Hockney establishes a sense of distance by alternating detailed renderings of trees, houses, tennis courts and power lines with more abstract planes of colour or simple grids that define the valleys below. Presented in the Royal Academy of Art's 1981 exhibition *A New Spirit in Painting*, this body of work brought Hockney into sharper critical focus as well as validating his commitment to figurative painting.

In 1982, after having been approached to make an exhibition of his personal archive of photography at the Centre Georges Pompidou

14. David Hockney painting *Mullholland Drive: The Road to the Studio* 1980

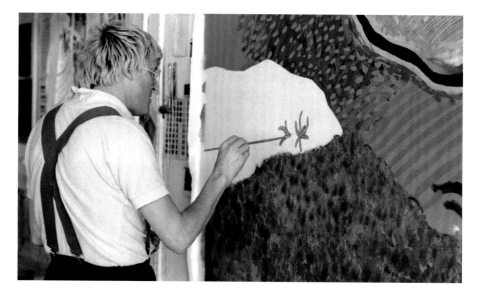

in Paris, Hockney temporarily abandoned painting and turned to photo-collage to investigate cubism, pictorial space and how to represent three dimensions in two, producing over 400 works in two years. *Billy & Audrey Wilder, Los Angeles, April 1982* 1982 typifies his method of arranging individual Polaroids of his subjects – taken from various angles and at varying distances – in a grid to create composite, multi-viewpoint temporal images (fig.42). In 1983, Hockney presented his ideas in his lecture 'On Photography', at the Victoria and Albert Museum, London, arguing against Renaissance one-point perspective in favour of many points of focus and many moments. After he switched to processed 35mm photographs taken on his Pentax to create 'joiners', Hockney's photo-collages developed even greater fields of vision, with edges that often spread beyond the format of a grid. In the spring of 1986 Hockney completed *Pearblossom Highway, 11–18 April 1986 #1* (fig.43). Playing with the perspective of the road which runs toward the distant mountains and the different perspectives of the surrounding details – aluminium cans, road signs, cacti, debris and rocks – it is the culmination of his experiments in this medium. Returning to painting, he attempted to give form – in interiors such as *Large Interior, Los Angeles* 1988 (fig.44) – to the sensation of moving in, through and around a room from many different vantage points and perspectives, as his revelatory discovery of Chinese scroll painting had confirmed was possible.

The road to Yorkshire

Despite losing a number of friends to the AIDS crisis of the 1980s and early 1990s, Hockney maintained a prolific practice as his work took on further profound changes in style and media. In 1985 he created a 41-page essay for *Vogue* magazine in France, made up of photo-collages, drawings, paintings and his own writings, and was invited to try Quantel Paintbox, a computer program for creating graphics, for a BBC programme, *Painting with Light*. The following year, Hockney produced his first home-made prints using an office-quality photocopier ('Because an office copier is a camera … a machine for printing'), in which he created layers of colour by putting each sheet repeatedly through the machine.[15] Later, at his Malibu beach house, Hockney began a series of paintings exploring the deep recessive space of the sea and small oil portraits of friends

and family members that are the size of photocopies. As part of the creative process, he began using a fax machine which he described as 'a telephone for the deaf' to distribute exhibitions of his work all over the world. He dispatched his 144- page composite image *Tennis* 1989 to the 1853 Gallery at Salts Mill, Bradford where the incoming pages were pasted to the wall in front of a live audience (fig.15).[16] Enjoying these simpler processes that, unlike conventional printmaking, did not rely on specialist workshops and assistants, he went on to make his first drawing on the computer using the Oasis programme for Apple Macintosh, which he printed on a laser colour printer. At the peak of his creative explorations, Hockney's provocative perceptions were reflected in the biggest exhibition of his work to date, *David Hockney: A Retrospective* which opened at the Los Angeles County Museum of Art in 1988, travelling to the Metropolitan Museum of Art, New York, and the Tate Gallery, London, where Hockney threatened to cancel the exhibition in protest at proposed anti-homosexual legislation.

Towards the end of the century, Hockney embarked on an unexpected series of 'Very New Paintings' that investigated recessional space and colour in a semi-abstract style. The geometry of works such as *The Eleventh Very New Painting* 1992 would inform his first explorations of the epic space of the Grand Canyon and his earliest paintings of Yorkshire (fig.46). Subsequently, *The Grand Canyon* 1998 (fig.49) and *Garrowby Hill* 1998 (fig.48) are some of his first paintings derived from direct observations of rural landscapes in which their

15. David Hockney
Tennis
1989
144-sheet composite image faxed to multiple venues including 1853 Gallery, Salts Mills, Bradford
Each sheet 21.6 × 35.6
Collection of the artist

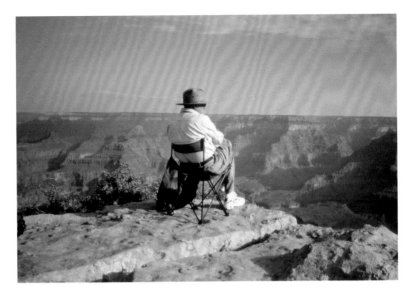

expansive space is elaborated by multi-points of view, sublime colour
and disappearing skylines. Landscape painting became a principle
focus for Hockney after 2000, when the artist spent increasingly long
periods in the small seaside town of Bridlington, East Yorkshire, where
he focused on painting the infinitely changing agricultural landscape
and seasons of the Yorkshire Wolds (fig.47). After writing his thesis
Secret Knowledge (2006) and composing his chronological timeline
of optically aided portraiture *The Great Wall* 2010, Hockney concluded
that the camera homogenises the world and discourages active
looking. As a result, he set out to search for ways to depict the world
differently from how the lens views it, placing himself in a longer
history of British landscape painters associated with areas of natural
beauty, including John Constable and J.M.W Turner.

Setting himself the challenge of painting in different and often
demanding conditions, Hockney initially focused on watercolour,
sketching from nature and then making medium-sized oil paintings
en plein air. This was followed by works such as *Elderflower Blossom,
Kilham, July 2006* 2006 (fig.50) – over three and a half metres wide –
that provided the first indication of the scale of Hockney's ambition to
find a way of painting out of doors on more expansive canvases, as his
experience of Constable's 'six-footers' at Tate Britain's exhibition that
year had problematised. In his 2006 series devoted to the Woldgate

17. David Hockney
drawing with the aid of
a camera lucida 1999

Woods, Hockney charted seasonal changes in this specific area of woodland in seven works each made up of six canvases, their three-point perspectives reminiscent of Van Gogh's *Wheatfield with Crows* 1890. Hockney painted each work from the same position, standing in the middle of a dirt road just before it branches out into three paths, disappears over a slight rise and then reappears in the distance, in a clearing where the light alters perspective and the perception of depth. Completed in two- or three-day sessions – on each day Hockney would set out his equipment, look carefully and then paint furiously – each picture is unlike any other (fig.52).

Formally, the appearance of these large-scale, multi-canvas landscapes recalls the fragmented forms of Hockney's photographic collages of the 1980s, their grid-like formation engulfing the viewer and inviting them to move around its space. By employing multiple canvases and allowing the gridlines between them to become a part of the work, Hockney moved beyond the natural limitations of painting, setting his illusionistic images with their vivid handling of paint against modernist concerns for flatness, the minimal and what the art historian Rosalind Krauss called the 'anti-real'. As Tim Barringer argued at the time of Hockney's landmark exhibition *A Bigger Picture* at London's Royal Academy of Arts in 2012, his Yorkshire landscapes offer a wry commentary on the demise of modernism, 'teasingly

18. David Hockney
painting *The Road to
Thwing, Late Spring*
May 2006

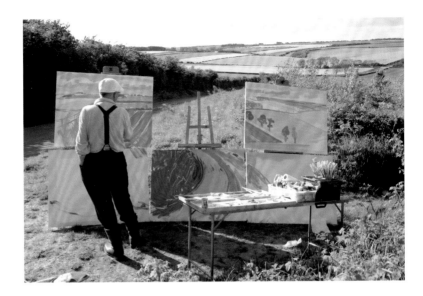

juxtaposing his illusionistic images with their saturated Fauvist colours, with a grid-like framework, the most recognisable symbol (in its pure form) of austere experiments in minimalism from Piet Mondrian to Donald Judd and Carl Andre.'[17]

Why nine cameras?

Having always been committed to the idea of art as a product of technique rather than history and drawn to unorthodox ways of making pictures, Hockney began to see the possibilities offered by the latest digital technologies. 'Technology has always contributed to art', he has said. 'The brush itself is a piece of technology, isn't it?'[18] Paradoxically, the challenging process of painting his Yorkshire landscape *en plain air* had been expedited when he began to employ a digital photographic reproduction technique that allowed him to study, as each work evolved, the assembled image of the painting in the studio prior to each new day's work in the landscape. Bridging the artist's commitment to traditional media and technical innovation, digital aids were employed on a greater scale for the monumental *Bigger Trees Near Warter, Or/Ou Peinture sur la Motif pour le Nouvel Age Post-Photographique* 2007, Hockney's largest ever painting, comprised of over fifty canvases. Here the title alludes to the technique, a combination of painting out of doors and in front of the subject

(called in French 'sur le motif') whilst also using the techniques of digital photography and Photoshop to enable him to track the progress of the composition (fig.51).

Between 2008 and 2009, Hockney worked like the Romantic landscape painters before him – from sketches and, increasingly, from memory. His move to a vast new warehouse studio in Bridlington enabled him to create ever more complex and expansive pictures, such as *Hawthorn Blossom Near Rudston* 2008. These paintings were produced in tandem with his first use of the Brushes app on his iPhone (fig.53) and later his iPad, which he began using to sketch views from his bedroom window or taking his device outside to work directly from a motif (fig.54). These works had the luminescence of stained glass when viewed on screen or from subsequent digital prints, and Hockney quickly discovered that the tablet's instant qualities could solve the problem, confronted by artists over the ages, of depicting the constantly changing light and seasons of the landscape: 'Turner would have loved it ... The light changes quickly here, so you have to choose how you want to depict it. I realised how fast I can capture it with the i-Pad, a lot faster than watercolour for example. Simply faster. You can choose a new colour or a new brush more rapidly. You don't have to wait for anything to dry.'[19]

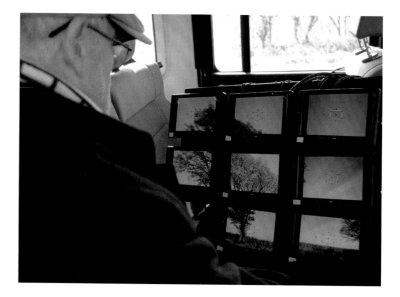

19. David Hockney
drawing with nine cameras
April 2010

In 2010, twenty-eight years after making his first photo-collages, Hockney extended composite imaging to video in order to make 'bigger pictures'. Arranging nine high-definition cameras in a grid on the front of his Jeep, he recorded the same journey through the Woldgate Woods during each of the four seasons. The result is an immersive installation presenting each season on nine digital video screens where the edges of the picture have been removed and in which it is impossible to see everything at once (fig.55). In *The Jugglers* 2014, the camera is taken to the studio to create a figurative work in which a troupe of jugglers demonstrate their skills in time and space (fig.58). Summing up his achievement and the impact of 'the pictures' that had stimulated him over sixty years ago, Hockney wrote, 'It is only very recently that technology has opened up the possibilities of new images, images far more interesting to look at than those from old cameras with fixed perspective. New kinds of narratives might emerge from these advances, as happened with the new movie camera ninety years ago. The television picture can't be fixed forever.'[20]

As Hockney approaches his eightieth birthday, his art and life feel as rejuvenated as ever. As he has said, 'I'm not a person of nostalgia. I just live for now.'[21]

20. David Hockney photographed for the *Observer* on 28 October 2014 in Los Angeles, California

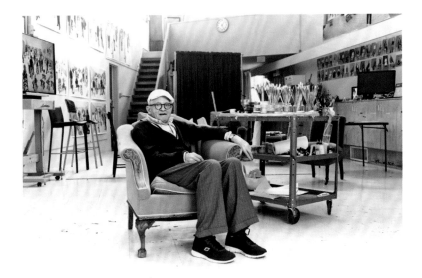

21. David Hockney
Shame 1960
Oil paint on board
126.8 × 101.5
Private collection

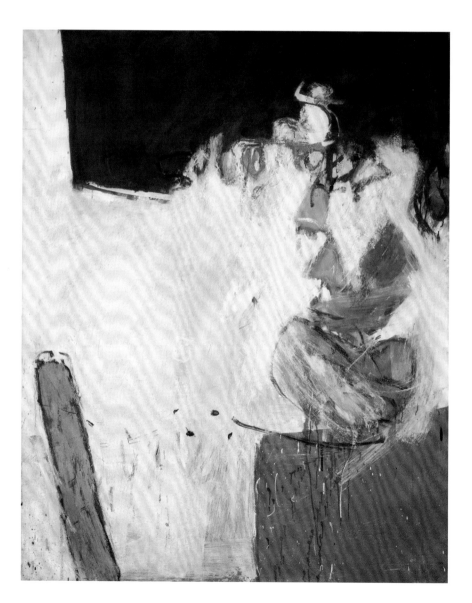

22. *The Third Love Painting*
1960
Oil paint on board
118.7 × 118.7
Tate

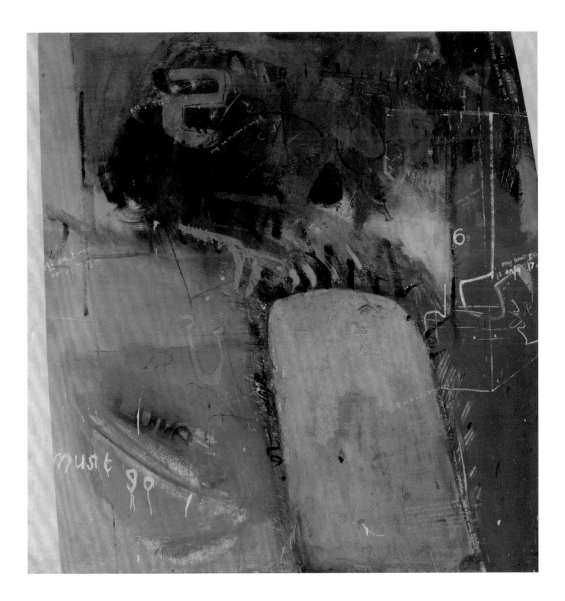

23. *Tea Painting in an Illusionistic Style* 1961
Oil paint on canvas
232.5 × 83
Tate

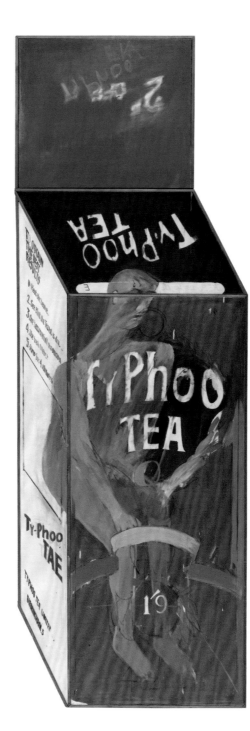

24. *Cleaning Teeth, Early Evening (10pm) WII* 1962
Oil paint on canvas
182.7 × 122
Astrup Fearnley Collection,
Oslo, Norway

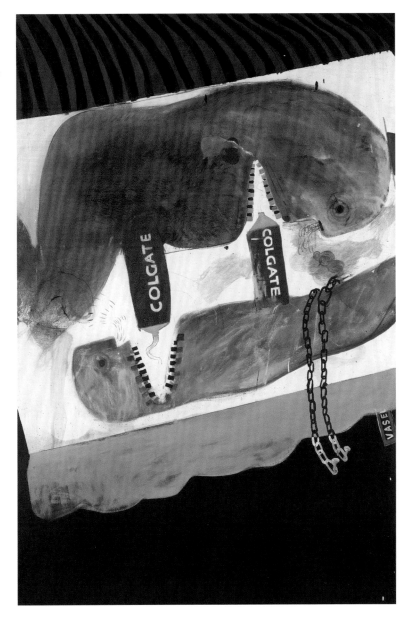

25. *Flight into Italy –
Swiss Landscape* 1962
Oil paint on canvas
189.2 × 189.2
Stiftung Museum
Kunstpalast, Dusseldorf

26. *The First Marriage*
(A Marriage of Styles 1)
1962
Oil paint on canvas
182.9 × 214
Tate

27. *Domestic Scene,*
Los Angeles 1963
Oil paint on canvas
153 × 153
Private collection

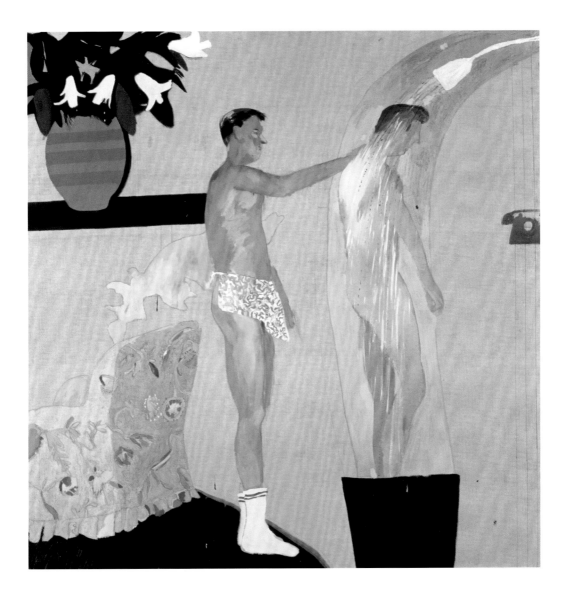

28. *Play within a Play* 1963
Oil paint and Plexiglass
on canvas
183 × 198
Private collection

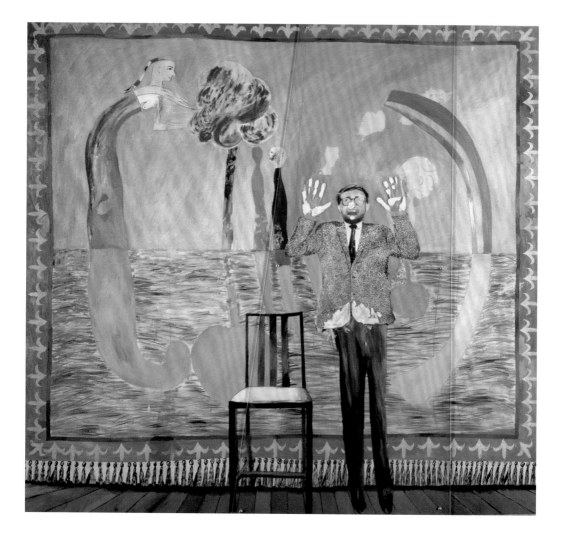

29. *Rocky Mountains
and Tired Indians* 1965
Acrylic paint on canvas
170 × 253
Scottish National Gallery
of Modern Art

30. *Peter* 1966
Graphite, coloured pencil
and ink on paper
29.2 × 64.8
Private collection, London

31. *Kasmin in his Bed in his Chateau, Carennac* 1967
Ink on paper
43.2 × 35.6
Paul Kasmin Gallery

32. *A Bigger Splash* 1967
Acrylic paint on canvas
242.5 × 243.9
Tate

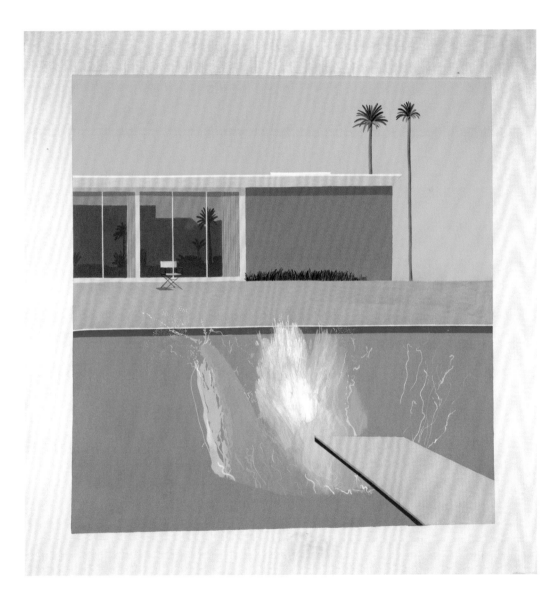

33. *Savings and Loan
Building* 1967
Acrylic paint on canvas
122 × 122
Smithsonian American
Art Museum

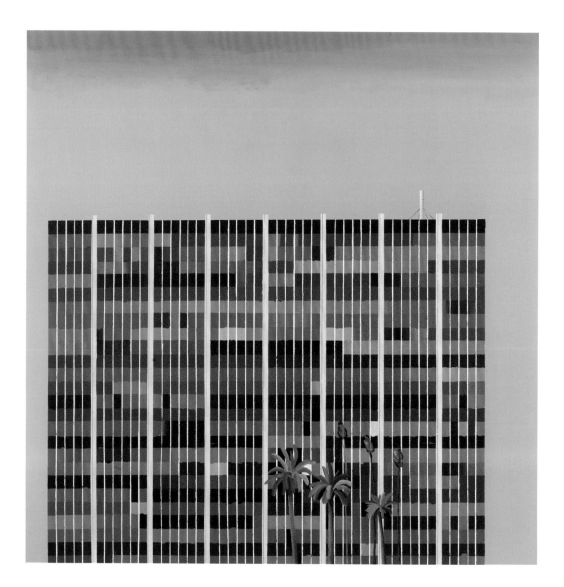

34. *Mr and Mrs Clark
and Percy*
1970–71
Acrylic paint on canvas
213.4 × 304.8
Tate

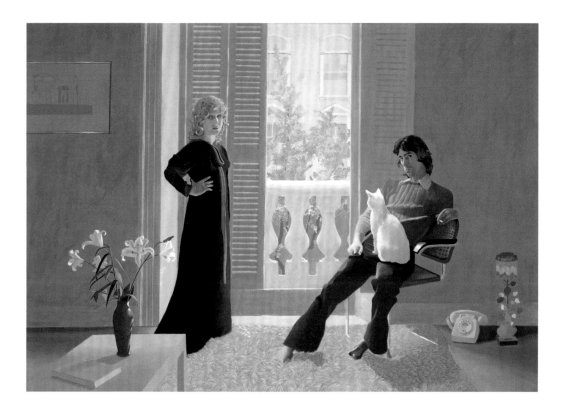

35. *Ossie Wearing a Fairisle Sweater* 1970
Crayon on paper
43.2 × 35.6
Private collection

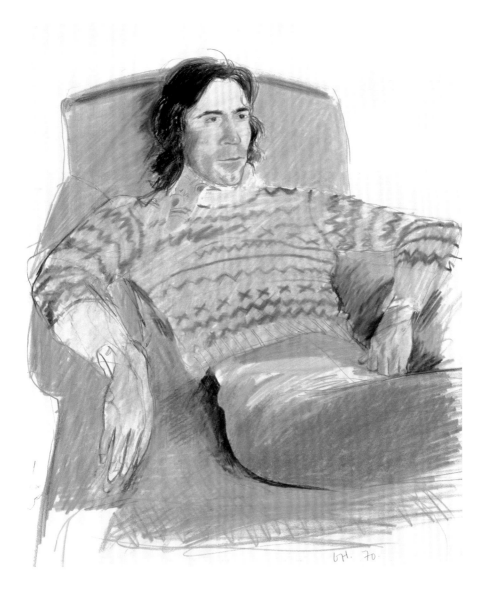

36. *Portrait of an Artist
(Pool with Two Figures)*
1972
Acrylic paint on canvas
214 × 304.8
Private collection

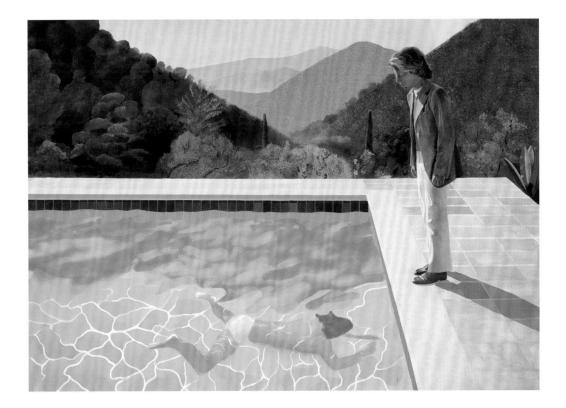

37. *Celia in a Black Dress
with White Flowers* 1972
Crayon on paper
43 × 35.5
Private collection

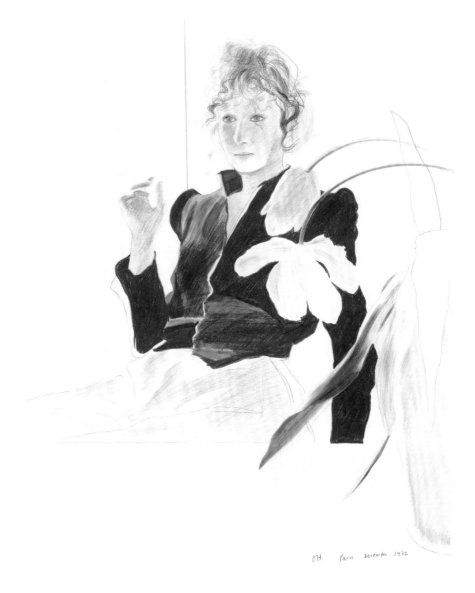

DH Paris December 1972

38. *Contre-Jour in the French style (Against the Day dans le style francais)*
1974
Oil paint on canvas
183 × 183
Ludwig Museum –
Museum of Contemporary
Art, Budapest

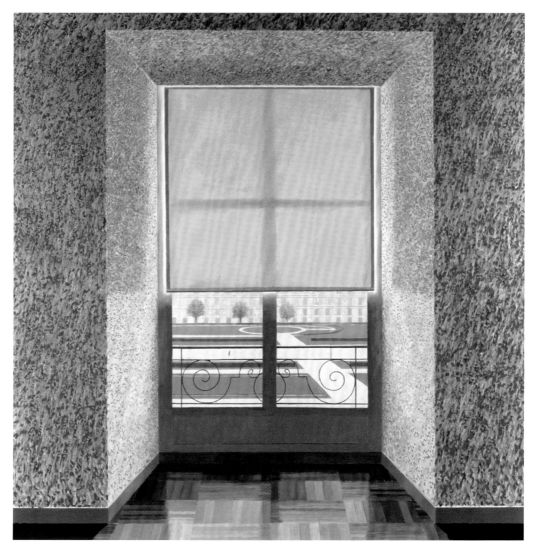

39. *Kerby (After Hogarth)*
Useful Knowledge 1975
Oil paint on canvas
183 × 152.4
Museum of Modern Art,
New York

40. *Canyon Painting* 1978
Acrylic paint on canvas
152.4 × 152.4
Private collection

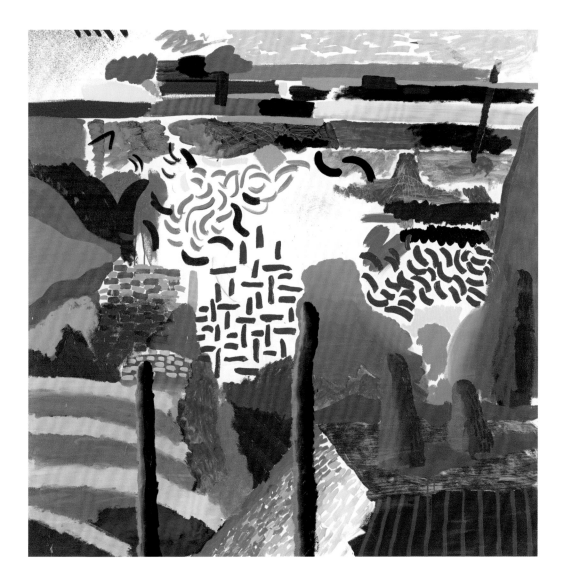

41. *Hollywood Hills House*
1981–82
Oil paint, charcoal and
collage on canvas
152.4 × 304.8
Walker Art
Center,Minneapolis

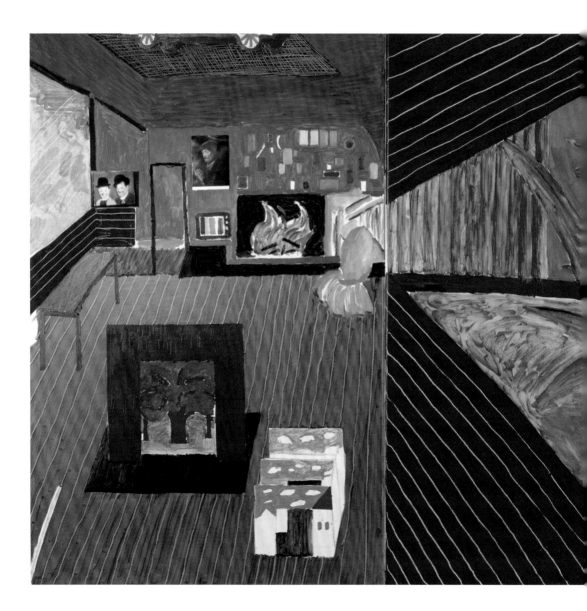

42. *Billy & Audrey Wilder,*
Los Angeles, April 1982
Composite Polaroid
116.8 × 111.8
Collection of the artist

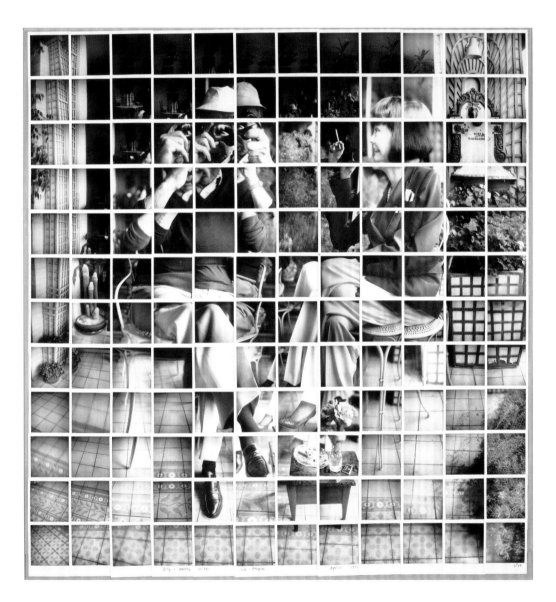

43. *Pearblossom Highway,*
11-18th April 1986 #1
Photographic collage
119.1 × 162.9
The J. Paul Getty Museum,
Los Angeles

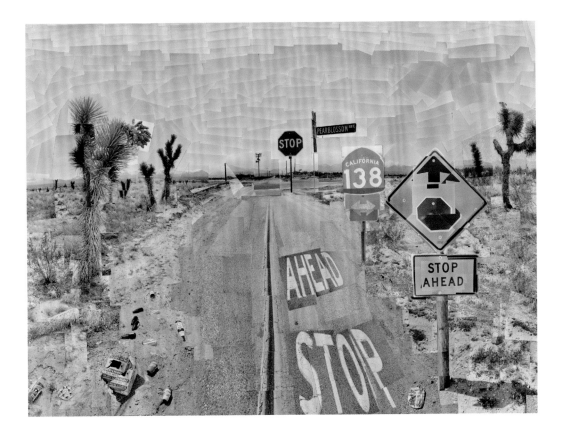

44. *Large Interior,*
Los Angeles 1988
Oil paint and ink on cut and
pasted paper, on canvas
183.5 × 305.4
Metropolitan Museum
of Art, New York

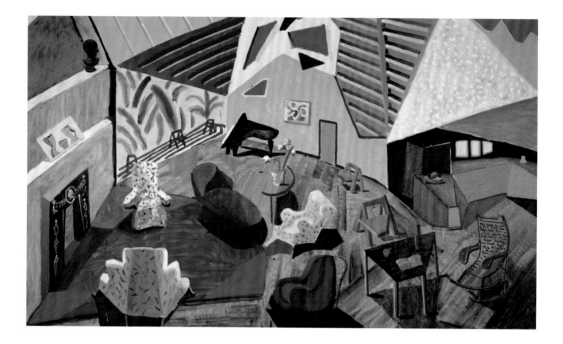

45. *Pacific Coast Highway
and Santa Monica* 1990
Oil paint on canvas
198 × 304.8
Private collection, USA

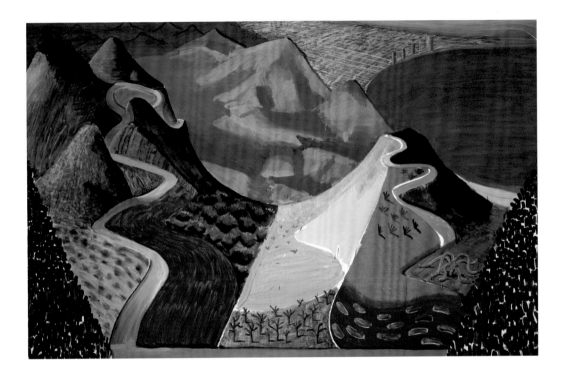

46. *The Eleventh V. N. Painting* 1992
Oil paint on canvas
61 × 91.4
The David Hockney
Foundation

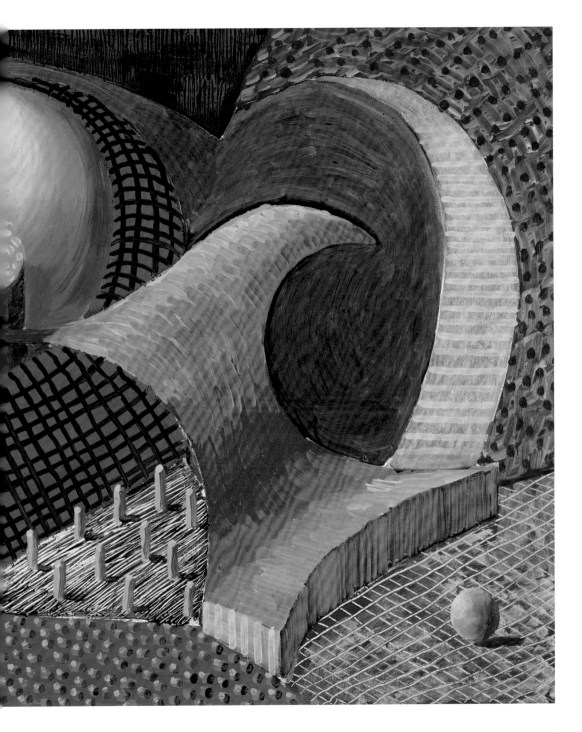

47. *The Road Across the Wolds* 1997
Oil paint on canvas
122 × 153
Private collection

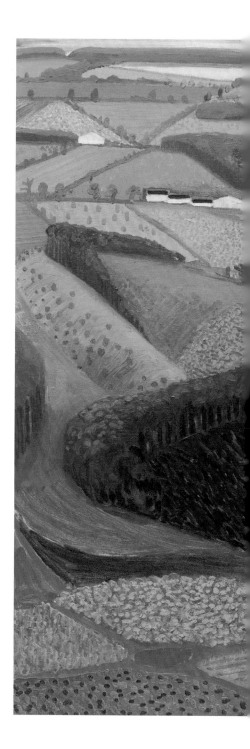

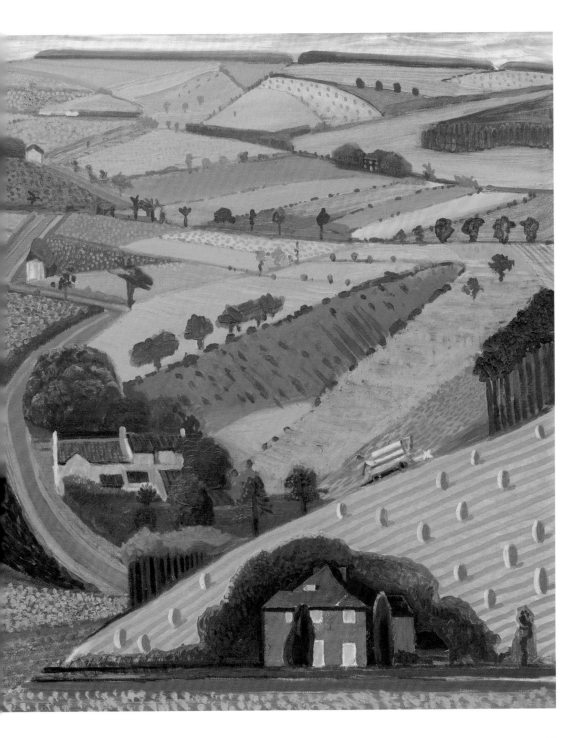

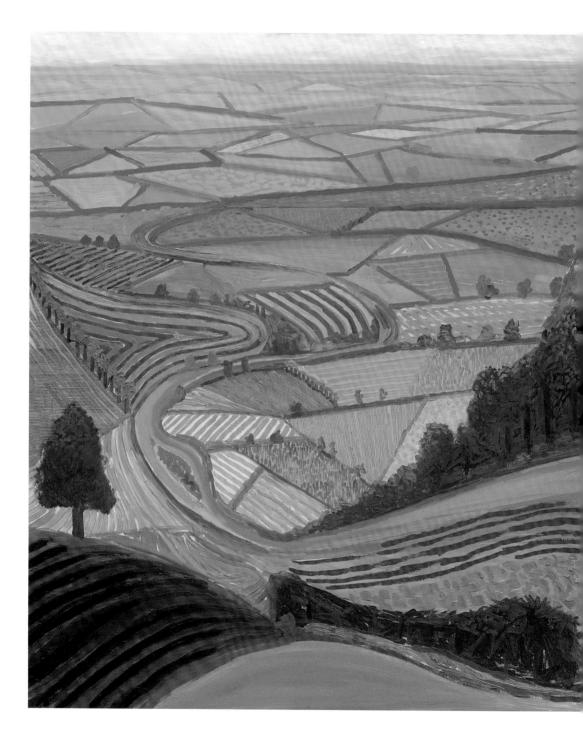

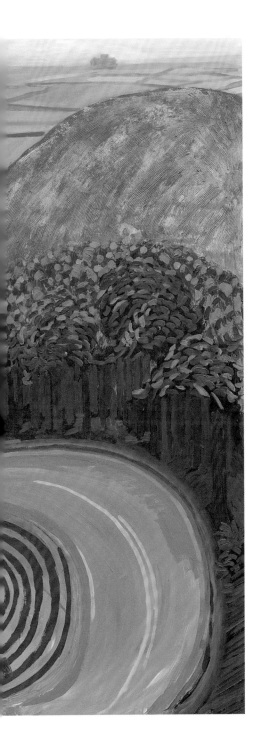

48. *Garrowby Hill* 1998
Oil paint on canvas
152.4 × 193
Museum of Fine Arts,
Boston

Following page:
49. *9 Canvas Study of
The Grand Canyon* 1998
Oil paint on nine canvases
100.3 × 168.9
Private collection

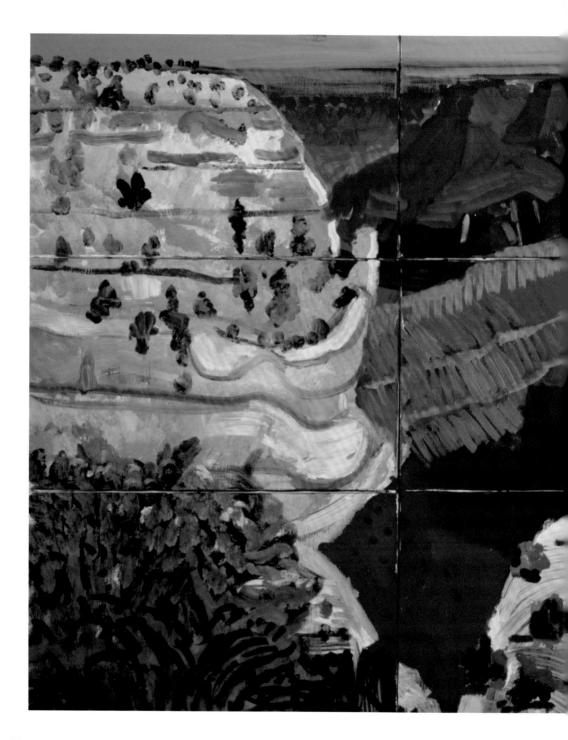

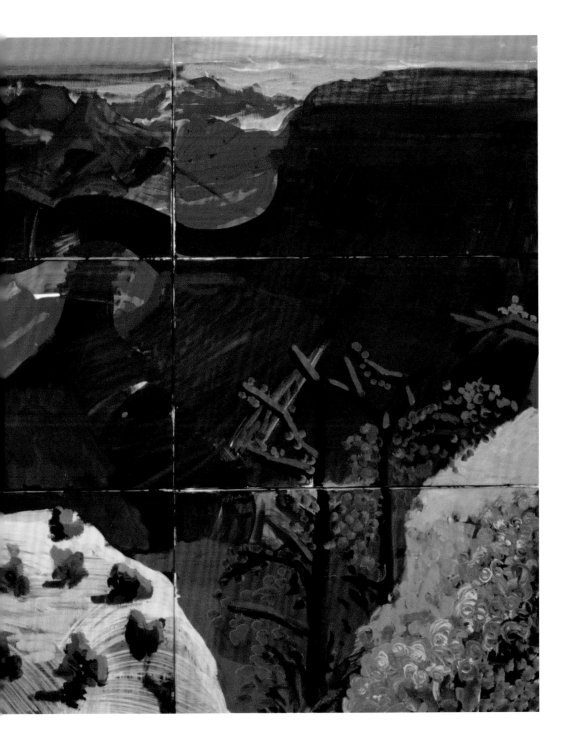

50. *Elderflower Blossom,*
Kilham, July 2006
Oil paint on two canvases
121.9 × 182.9
Private collection

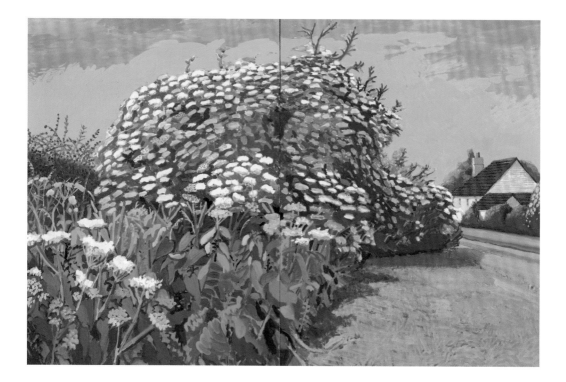

51. *Six Part Study for*
Bigger Trees 2007
Oil paint on six canvases
182.9 × 365.8
Collection of the artist

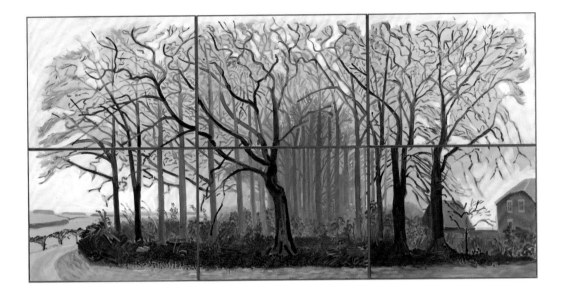

52. *Woldgate Woods,*
6 & 9 November 2006
Oil paint on six canvases
182.9 × 365.8
Collection of the artist

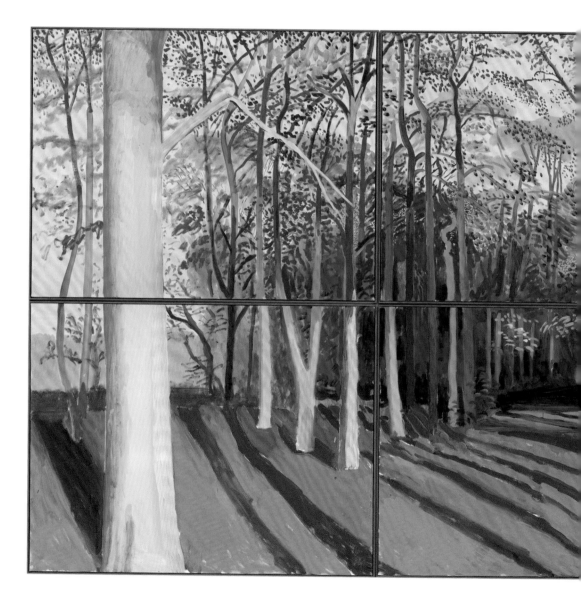

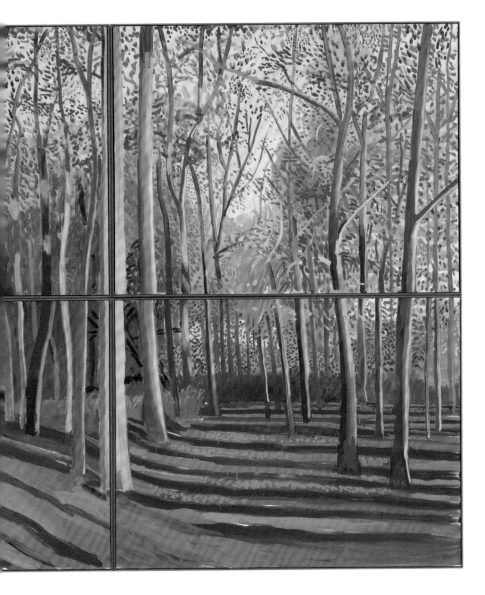

53. *Glyndebourne*
Bedroom by Day 2010
(330)
iPad drawing
Collection of the artist

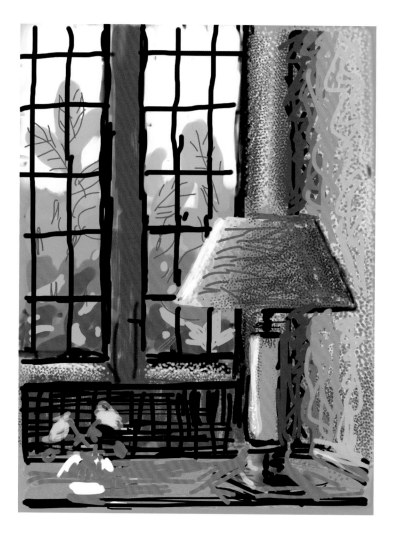

54. *The Arrival of Spring in*
Woldgate, East Yorkshire in 2011
(twenty eleven) – 18 December
iPad drawing printed on
4 sheets of paper, mounted on
4 sheets of Dibond
236.2 × 177.8. Edition of 10
Collection of the artist

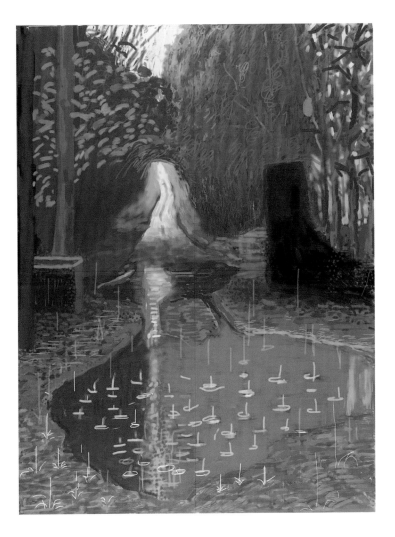

55. *The Four Seasons,*
Woldgate Woods, (Spring
2011, Summer 2010, Autumn
2010, Winter 2010) 2010–2011
36 digital videos synchronised
and presented on 36 monitors
Duration 4:21
205.7 × 145.8. Edition of 10
Collection of the artist

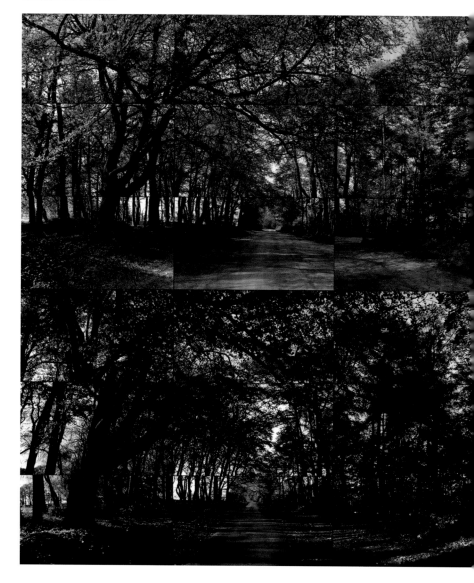

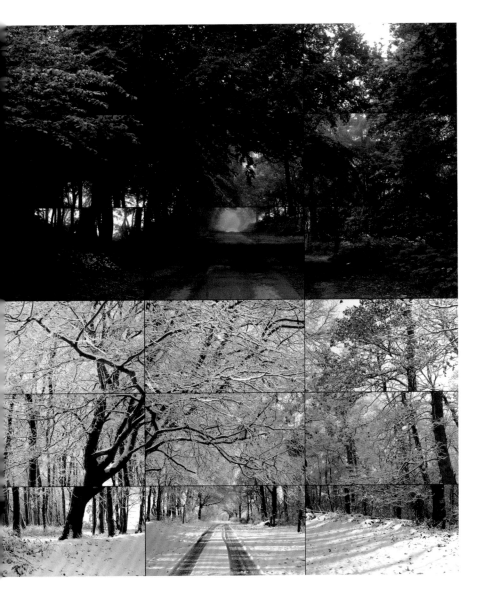

56. *Woldgate 16 & 26 March 2013*
from *The Arrival of Spring in 2013*
(twenty thirteen)
Charcoal on paper
57.5 × 76.7
David Hockney Foundation

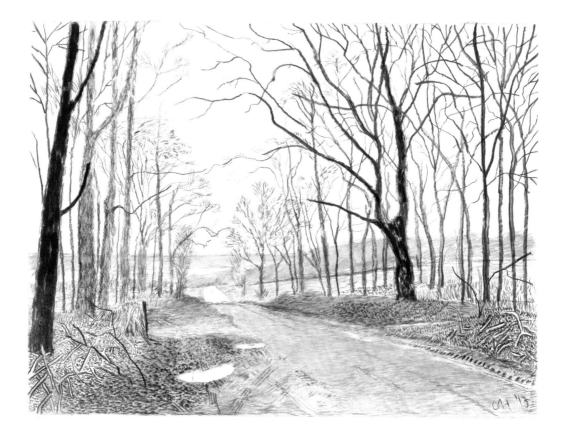

57. *Woldgate 15–16 May 2013*
from *The Arrival of Spring in 2013*
(twenty thirteen)
Charcoal on paper
57.5 × 76.7
Collection of the artist
David Hockney Foundation

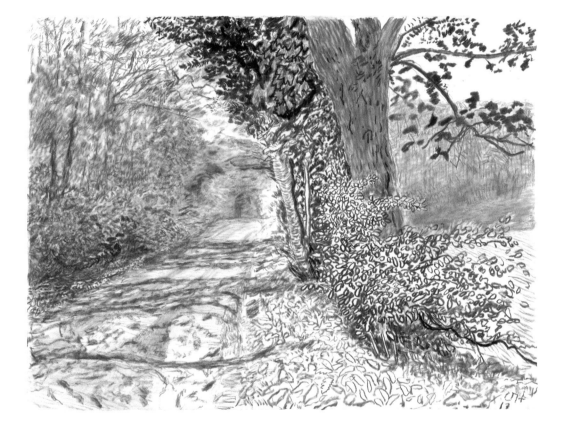

58. *The Jugglers 2012*
18 digital videos
synchronised and
presented on 18 55 inch
monitors
Duration 22: 18
205.7 × 729
Edition of 10
Collection of the artist

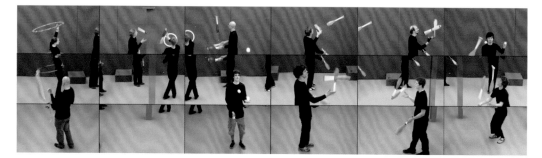

59. *4 Blue Stools* 2014
Photographic drawing
printed on paper, mounted
on Dibond
107.9 × 176.5
Edition of 25
Collection of the artist

60. Garden with
Blue Terrace 2015
Acrylic paint on canvas
121.9 × 182.8
Private collection

Notes

1. David Hockney in David Hockney and Martin Gayford, *A History of Pictures: From the Cave to the Computer Screen*, London 2016, p.19.

2. Conversation with the author, London, June 2016.

3. David Hockney quoted in Randall Wright (dir.), *Hockney*, Blakeway and Fly Film Production for BFI, BBC Arts, Screen Yorkshire, British Film Company and the Smithsonian Channel, 110 mins, 2014.

4. The four paintings were titled: *Demonstration of Versatility – A Grand Procession of Dignitaries in the Semi-Egyptian Style* 1961; *Demonstration of Versatility – Tea Painting in an Illusionistic Style* 1961; *Demonstration of Versatility – Figure in a Flat Style* 1961 and *Demonstration of Versatility – Painting in a Scenic Style* 1962.

5. David Hockney in conversation with Larry Rivers in *Art and Literature*, no.5, Summer 1965.

6. David Hockney, quoted in Marco Livingstone, *David Hockney*, London 1981, pp. 52–3.

7. David Hockney, quoted in Nikos Stangos (ed.), *David Hockney by David Hockney*, London 1976, p.90.

8. See Edmund White, 'The Lineaments of Desire', in *David Hockney Portraits*, exh. cat., National Portrait Gallery, 2006, p.53.

9. Paul Melia (ed.), *David Hockney*, Manchester 1995, p.9.

10. Charles Harrison, 'London Commentary: David Hockney at Kasmin', *Studio International*, vol.175, no.896, Jan. 1968, pp. 36–8.

11. Christopher Knight, 'Composite Views: Themes and Motifs in Hockney's Art', in *David Hockney: A Retrospective*, exh. cat., Los Angeles County Museum of Art, Los Angeles 1988.

12. 'David Hockney in conversation with R. B. Kitaj', The New Review, January/February 1977, pp.75–7.

13. David Hockney, 'No Joy at the Tate', the *Observer*, 4 March 1979.

14. David Hockney, quoted in Lawrence Weschler, 'A Visit with David and Stanley, Hollywood Hills, 1987' in *David Hockney: A Retrospective*, exh. cat, Los Angeles County Museum of Art, 1988, p.77.

15. Quoted from the artist's website: http://www.hockneypictures.com/illust_chronology/illust_chrono_06.php

16. Tim Barringer, 'Seeing with Memory: Hockney and the Masters', in *David Hockney: A Bigger Picture*, exh. cat., Royal Academy of Arts, London, 21 Jan. – 9 April 2012, p.50.

17. Quoted in Martin Gayford, 'David Hockney: The Technology of Art,' in *David Hockney: A Bigger Picture*, exh. cat., The Royal Academy of Arts, p.62.

18. Ibid, p.67.

19. Ibid, p.270.

20. Quoted in Simon Garfield, 'Time, Gentlemen', *Independent*, 25 July 1992.

Index

First published 2017 by order of the Tate Trustees by
Tate Publishing, a division of Tate Enterprises Ltd,
Millbank, London SW1P 4RG
www.tate.org.uk/publishing

A catalogue record for this book is available from
the British Library

ISBN 978 1 84976 500 8

Designed by Anne Odling-Smee, O-SB Design
Colour reproduction by DL Imaging Ltd, London
Printed by Graphicom Srl, Italy

Frontispiece: *Outpost Drive, Hollywood* 1980, Acrylic
paint on canvas, 152.4 × 152.4, Private collection
Cover: *A Bigger Splash* 1967 (detail, fig.32)

Measurements of artworks are given in centimetres,
height before width.

Copyright credits
All works by David Hockney © David Hockney 2017

Photo credits
Art Gallery of New South Wales / Jenni Carter fig.36
Christie's fig.24
© Condé Nast Ltd - Cecil Beaton / Trunk Archive fig.7
Prudence Cuming Associates figs.26, 39, 43, 47,
frontispiece
© Craig Easton fig.13
© Tony Evans/Timelapse Library Ltd. / Getty Images
fig.1
Jean Pierre Gonçalves de Lima figs.16, 18, 19
© Dennis Hopper, Courtesy of The Hopper Art Trust
fig.8
© Mirrorpix fig.9
© Geoffrey Reeve fig.4
© Phil Sayer fig.17
Richard Schmidt figs. 3, 22, 23, 34, 42, 46, 49, 51, 52,
56, 57, 59, 60
© Steve Schofield / Contour By Getty Images fig.20
© Wayne Shimabukuro fig.14
Smithsonian American Art Museum fig.33
Sotheby's figs.30, 40